# A Dog's Life

# A Dog's Life

*Hannah Dale*

BATSFORD

*For Auntie Susan, Paul and Charlotte*

First published in the United Kingdom in 2016 by
Batsford, an imprint of B. T. Batsford Holdings Limited

This edition first published in 2024 by Batsford Books

43 Great Ormond Street, London WC1N 3HZ

ISBN: 9781849949255

A CIP catalogue record for this book is available
from the British Library.

10 9 8 7 6 5 4 3 2 1

Reproduction by Mission Productions, Hong Kong

Printed and bound by Toppan Leefung Printing Ltd, China

This book can be ordered direct from the publisher at the
website www.batsfordbooks.com, or try your local bookshop.

# Contents

# Introduction

They are our best friends, confidants, companions, guardians, family members and playmates. They instinctively know how we are feeling and have an incredible ability to cheer us up when we feel down, or share in our delight when we are happy. What's more, they invoke in us the most powerful feelings of love and affection that are always reciprocated wholeheartedly. The relationship between us and our dogs, and our ability to communicate with one another, is as unique as it is remarkable, and it's fascinating to think about how this bond originally began to form many thousands of years ago as our hunter-gathering ancestors first made friends with wolves, never imagining we would go on to forge the relationships we have today.

My first step in researching this book was to speak to as many dog owners as possible to get a feeling for the personality and nature of each breed. This proved to be utterly fascinating – the passion and love each owner has for his or her favourite cannot be overstated. It quickly became clear that there is a perfect dog for everyone, whether your idea of heaven is to be out in the fresh air from morning until noon, or if you prefer to be snuggled quietly indoors enjoying some home comforts.

When I asked the question online, 'What are the three words that best describe your dog?' the response was overwhelming and I soon had thousands of replies, with the most diverse and wonderful array

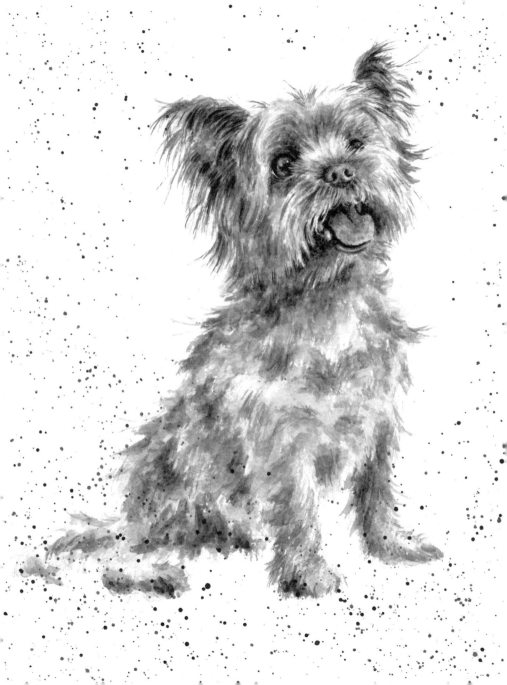

of adjectives as well as many photos of much-loved dogs, stories and anecdotes. It was so inspiring to read all of these passionate messages, and I became quite addicted. I spent most of our family holiday with my head in my laptop recording each of the 6,000 responses in a notebook for future reference. The words you see at the top of each page describing the character of each breed are taken from this work – who better to describe the breed than the people who know and love it best? I returned to my notebook each time I started work on a new breed and tried to immerse myself in the comments and words describing the dogs, spending time with the real thing too, where possible. I kept trying to pick a favourite breed, but became so involved with each new one that I kept changing my mind.

The most common word people used to describe their dog, regardless of the breed, was 'affectionate', and this probably best describes why we are so attached to our dogs. They provide us with unconditional affection and love. The need to be needed is irresistible and it's not hard to see why we humans desire these relationships, unhampered by the complications often accompanying our human ones. There's evidence to show that we choose our dogs in a similar way to how we choose partners, love them in the same way we love our children, and even that dogs actually do look like their owners! There is little wonder that our dogs play such an important role in our lives.

This book has been an absolute pleasure to research, write and paint. I have always loved painting animals of any kind, and naturally dogs have featured heavily in my work over the years, but it has been quite an education to be focused solely on one kind of animal for so long. It's hard to imagine an animal that embodies so much personality and character as a dog, and the challenge for me was to interpret this in my paintings. I hope that I have done justice to your favourite breeds and captured some of the personality that is so abundant in our canine companions. Lastly, I owe an enormous debt of gratitude to all of my family and friends who allowed me to paint their gorgeous pooches. Thank you!

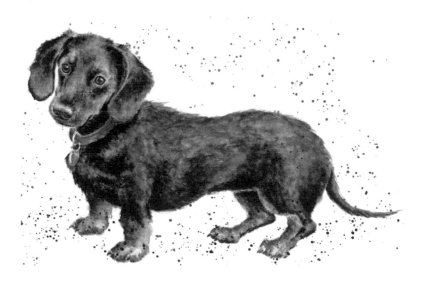

# Companion Dogs

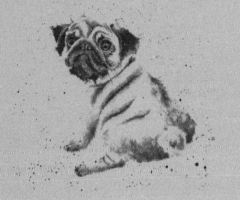

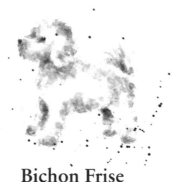

# Bichon Frise
*Nosy • Sociable • Alert*

The diminutive white Bichon is often mistaken for a Poodle with its fluffy, powder-puff coat, but is a very old breed in its own right. As is often the case, its exact origin isn't known, but it is thought that it is related to other similar dogs such as the Maltese and the Bolognese, and that it hailed from the Mediterranean, being transported to other countries along the trade routes taken by sailors. The Bichon is a happy little dog, affectionate and gentle and loves to play. It is not aggressive so makes a wonderful family pet. It is very energetic and needs a fair amount of daily exercise.

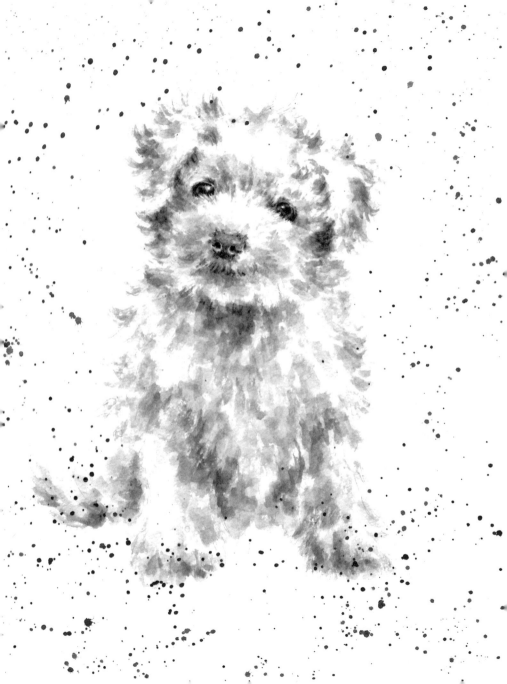

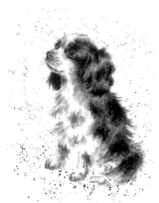

# Cavalier King Charles Spaniel
*Attentive • Sweet-tempered • Gentle*

This little dog has a royal heritage and no self-respecting court lady
in Tudor or Stuart times would be seen without one. The direct
ancestors of the 'Cav' were particularly loved by their namesake,
King Charles II. He was rarely spotted without several of these
handsome little dogs at his heels. The Cav has four recognised
colours – the equally regal sounding Blenheim (chestnut and white),
tricolour, black and tan, and ruby. There is no wonder that the Cav
has become such a popular family pet. Friendly and fun-loving,
equally happy with a romp around the garden and a snuggle by
the fire, it makes a wonderful all-round companion.

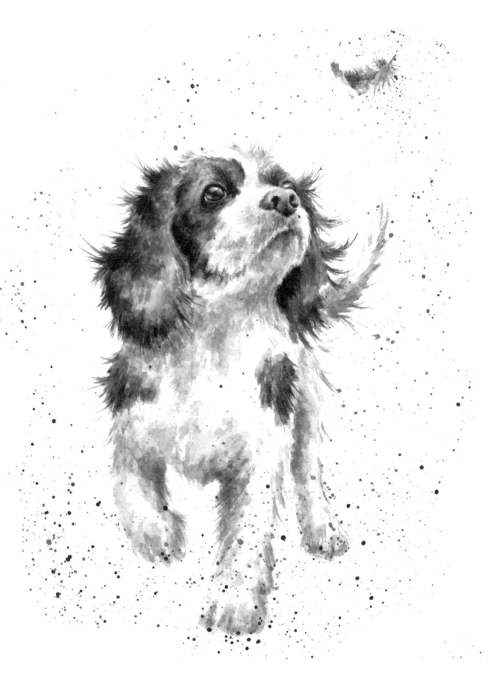

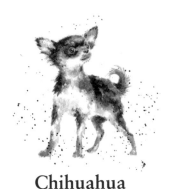

# Chihuahua
*Lively • Funny • Entertaining*

The Chihuahua is the little dog with a big personality. Comical and entertaining, full of character and eccentricity, the Chihuahua also has a reputation for being something of a diva, and certainly likes to be pampered. They much prefer the company of other Chihuahuas over different breeds – they love to play together, cuddle and lick one another's ears. They enjoy warmth and are almost cat-like in their ability to select the warmest spot in a room.

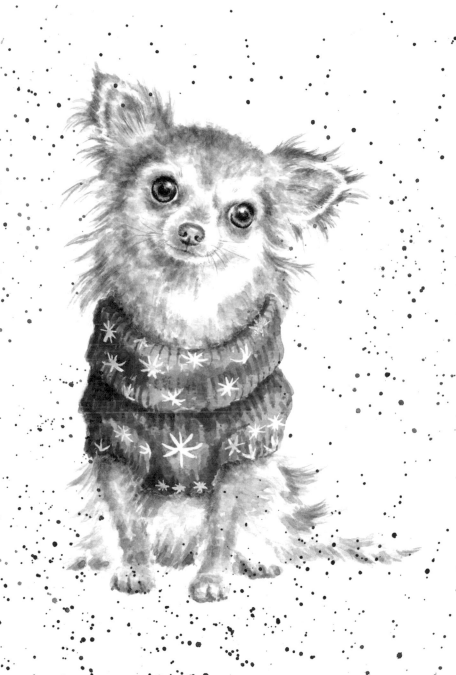

# Cockapoo
*Excitable • Wilful • Affectionate*

Cockapoos are hybrid dogs, created by breeding a Cocker
Spaniel with a Poodle. They love their owners unconditionally
and will want to play with them from dawn until dusk. They are
intelligent and fun-loving, but don't shed quite as much hair as
a Cocker Spaniel. The Cockapoo is not recognised as a distinct
breed but irrespective of this is a hugely popular pet combining the
loving and outgoing personality of a Cocker with the intelligence
and hypoallergenic coat of a Poodle. However, being a hybrid, its
character traits and appearance can be hugely variable, with some
being more Poodle or Cocker-like than others.

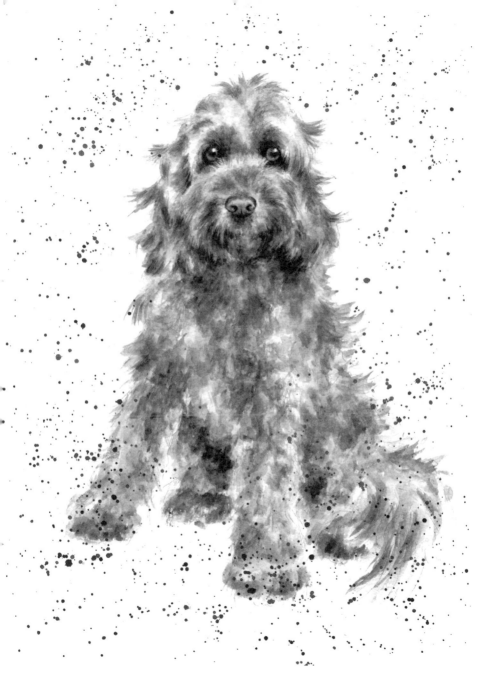

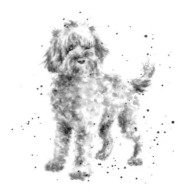

# Labradoodle
*Friendly • Intuitive • Joyful*

The Labradoodle first made its appearance in the 1950s and its popularity as a family pet has grown and grown. The cross of a Labrador and a Poodle, it was originally bred to combine the friendliness and intelligence of a Labrador with the low-shedding characteristics of a Poodle. The result is a smart, sociable and intelligent dog that loves swimming and is good with children. As with the Cockapoo, many of the Labradoodle's characteristics are dependent on whether they are more 'Labra' or 'Doodle'. Although they can vary greatly in nature and looks, there is no denying the popularity of the Labradoodle, and its fun-loving, gentle nature means it has won a firm place in our hearts.

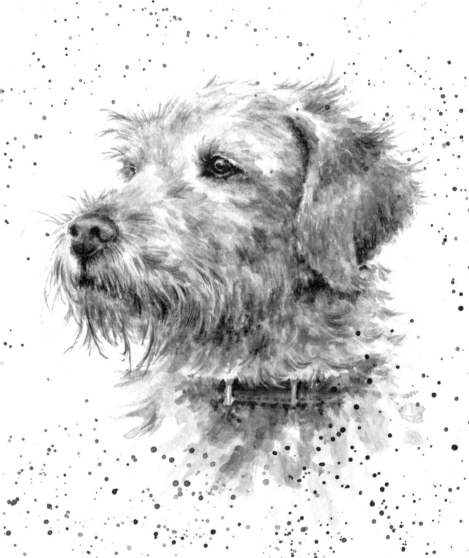

# Pug
*Funny • Childlike • Charming*

There can't be many who can resist a charming Pug, staring up at
you with those big, liquid brown eyes from a sweet, wrinkled face.
This is a dog used to getting its own way. Originating in China, they
were prized by Emperors and treated like Kings and Queens – some
even had their own soldier guards. Since then, they have been loved
by royalty all over the world – Queen Victoria and Marie Antoinette
were both devoted to their Pugs. Bred to be a lapdog, the Pug thrives
on human companionship and is happiest when sitting on your
knee. A natural show-off, they don't need a lot of exercise and will
be quite happy lazing most of the day away. Like most short-nosed
dogs, they are snufflers, snorers and grunters, talking to their owners
in their own unique way.

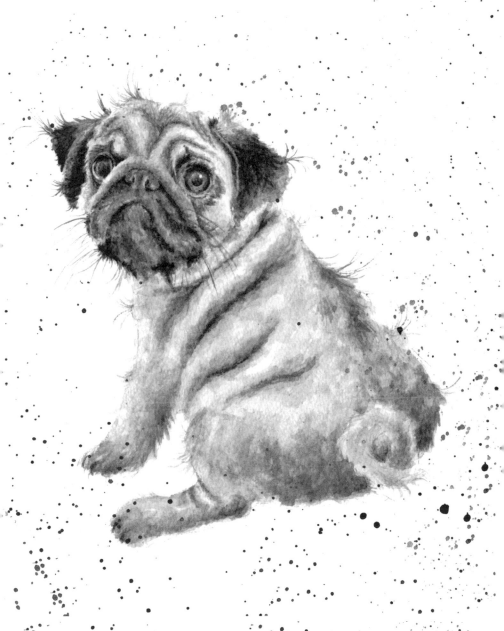

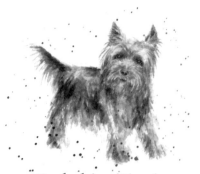

# Yorkshire Terrier

*Intelligent • Tireless • Vocal*

The little Yorkshire Terrier is a delicate, elegant dog with a
lively and loving personality, but has a tendency to be a little
highly-strung at times. The Yorkie came about in the nineteenth
century when Scottish mill workers brought their terriers to mills
and factories in Yorkshire, to catch rats and vermin. These dogs
were originally called 'Scotch Terriers', but the name was changed
in 1870 as, although it came from Scotland, the breed was originally
developed in Yorkshire. It is thought that a Yorkie named Smoky
was the first 'therapy dog'. She was found by an American soldier
during the Second World War, and after the war toured hospitals in
America, visiting wounded soldiers.

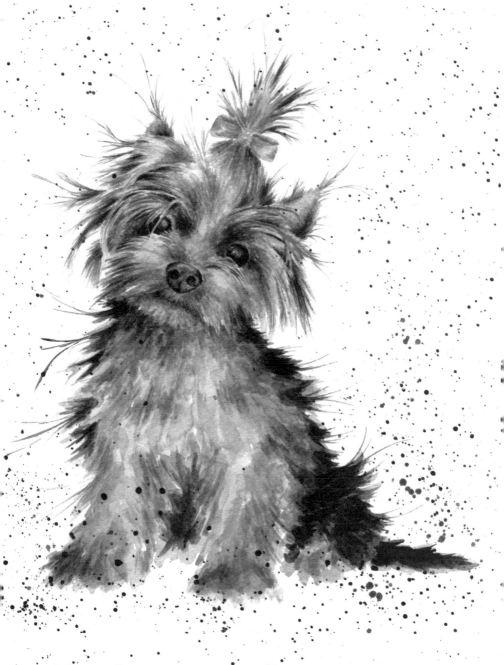

# Sporting Dogs

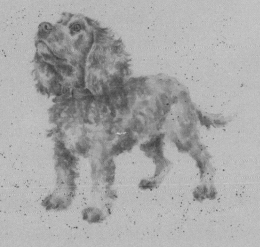

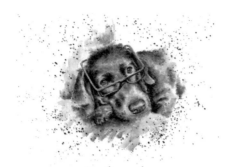

# Labrador
*Bouncy • Eager to please • Loyal*

The Labrador is the world's most popular dog; truly Man's Best
Friend. With its gentle nature, playful personality and bright
intelligence, it is no wonder that the Labrador is so loved. Perfect
as a family pet, these adaptable, clever dogs are also prized as
therapy dogs, detection dogs and sporting companions. Originally
hailing from Newfoundland in Canada, their ancestors belonged
to fishermen who had a deep reliance on their four-legged friends.
Known as the 'St John's Water Dog', they were responsible for
retrieving nets, ropes and even fish. Spotting their considerable
talents, two English aristocrats brought a pair of dogs to England
and bred them as shooting companions and soon realised that they
had something pretty special... and the rest of the world
wholeheartedly agrees.

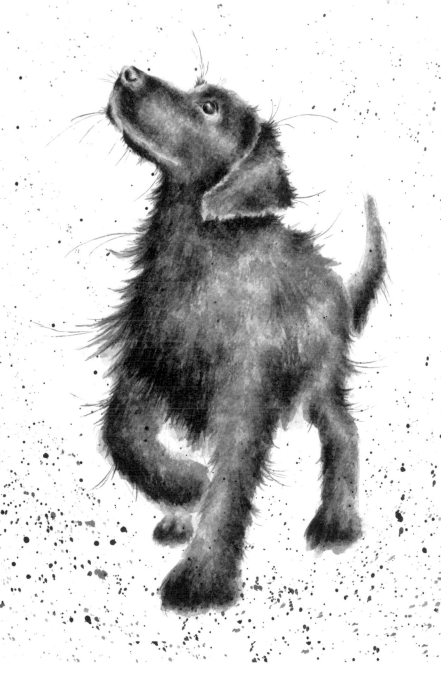

# Cocker Spaniel
*Bright • Characterful • Devoted*

The Cocker Spaniel is a very popular family pet, with its happy disposition and constantly wagging tail. It is thought that the name comes from 'woodcock' as it was originally used to drive game towards the guns. The Cocker comes in two distinct types, the field variety and the show variety – the two can vary quite considerably in appearance. The show Cockers having more compact bodies, longer ears and heavier coats while the working types tend to be more athletic in build, making them perfectly adapted to a long day in the field. When it comes to shows, the luscious Cocker Spaniel is the most successful breed in the top category at Crufts. Devotees include Prince William and the Duchess of Cambridge, who have a black Cocker Spaniel called Lupo.

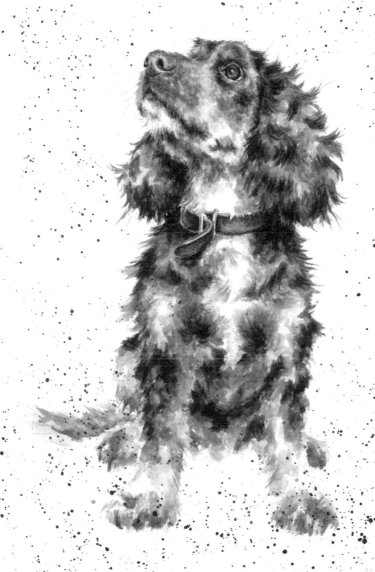

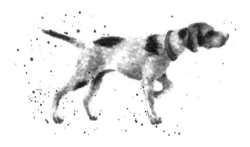

# German Short-haired Pointer
*Protective • Intelligent • Energetic*

As the name would suggest, this dog originated in Germany in
the nineteenth century, though its exact heritage isn't known. With
its beautiful, unique markings, it was developed to be a family
member as well as an expert hunter and this combination has led to
the breed being a popular choice for families that enjoy an active,
outdoor life. Hugely energetic, and requiring large amounts of
exercise to keep it happy and healthy, it is streamlined and powerful
with a strong muzzle, enabling it to retrieve heavy game. It also has
webbed feet, making it an excellent swimmer and all-round sporting
star. With its model looks, loving personality and sporting prowess,
it is little wonder that the GSP has become a popular pet as well as a
prized hunting companion.

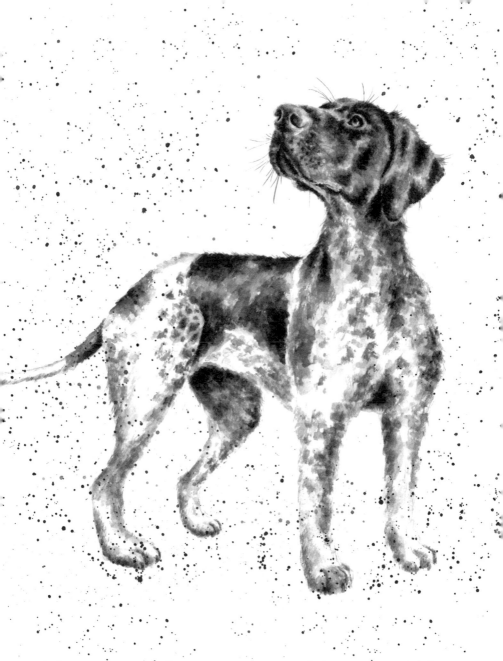

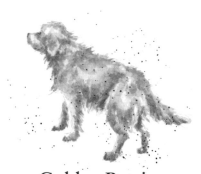

# Golden Retriever
## *Sweet • Laid-back • Brave*

It's hard to find a more perfect family pet than a Golden Retriever. The ultimate in kind, sweet and adorable, there isn't much to dislike about this wonderful breed. As the name would indicate, the Golden Retriever was originally bred to retrieve shot game, carrying it gently in its mouth, so not to cause any damage to the bird. The breed was developed in Scotland in the mid-nineteenth century with the intention of creating a dog that was able to retrieve from both land and water, which was necessary due to the marshy terrain. Retrievers love water and are very easy to train due to their bright nature. Characterised by their thick, wavy and waterproof coats, the friendly and gentle Retriever is an all-round good egg.

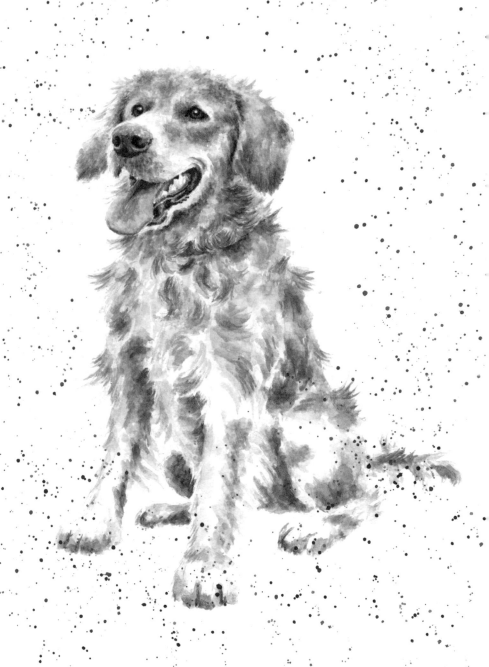

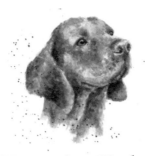

# Hungarian Vizsla
*Majestic • Demonstrative • Agile*

The copper coloured Vizsla is the supermodel of the canine world.
Sleek and athletic with a beautiful face and rich, russet coat, the
Vizsla is a very old Hungarian breed, and is an excellent pointer
and retriever. It is also a very good swimmer, though may take
some persuasion to venture into the water. It has no undercoat,
so is no fan of the cold and is not a dog that can be left outside.
Like the Weimaraner, it was bred for the nobility and as a highly-
prized animal it would have been kept inside with the family, so it is
incredibly dependent on human company. In fact, it is so devoted to
its owners that it likes to be in constant physical contact, hence the
nickname 'velcro dog'.

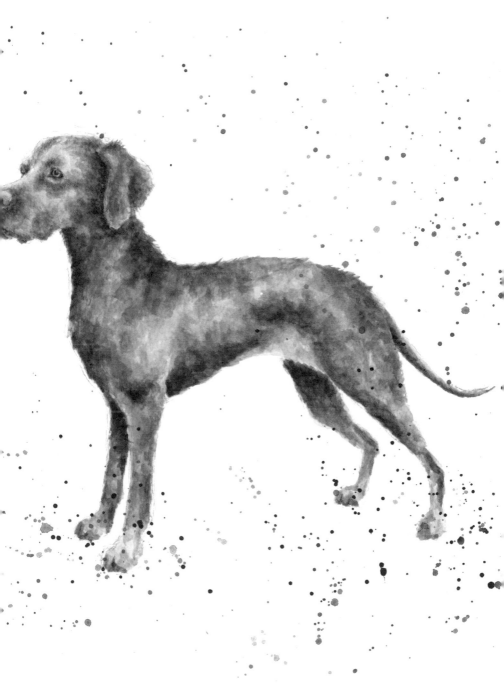

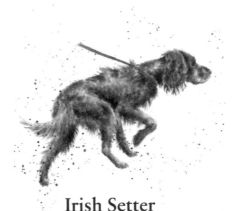

# Irish Setter

*Fun • Inexhaustable • Impulsive*

Life is just one big party for these flame-haired beauties. Playful and boundlessly energetic, they have a puppy-like enthusiasm giving them a distinctively mischievous streak. It is not until old age that they mature with a regal dignity, fitting for these aristocratic dogs. The Irish Setter is the oldest of the Setter group, being bred in the eighteenth century in Ireland as a bird dog for locating and pointing game. Blessed with a good sense of smell and enormous stamina, the Irish Setter enthusiastically sniffs out the birds from great distances, tracks their location and then silently freezes in place, revealing their location to the hunter. As a pet, the Irish Setter makes a lively and affectionate family member who will always be delighted to see its owner, and is always ready for some fun.

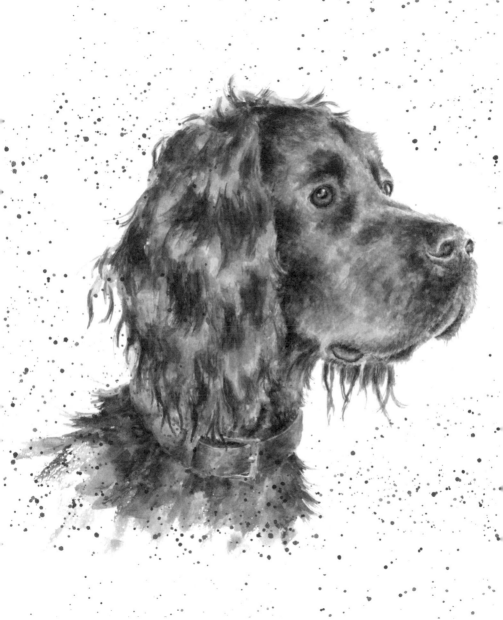

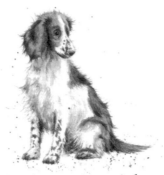

# Springer Spaniel
*Clever • Playful • Ditzy*

The adorable Springer Spaniel was used to flush (or 'spring')
game from the undergrowth during shoots. It is an obedient and
friendly dog that just wants to please and has excellent stamina. The
most popular Springers are the Welsh and English versions. Up to
the year 1800, there was no real distinction between Springer and
Cocker spaniels. In fact, they could be born in the same litter, with
the smaller pups being used to hunt woodcocks (the Cocker) and the
larger ones being used to flush game. It wasn't until 1801 that it was
suggested that the breeds were defined by their functions and they
began to be bred separately. As well as being a popular family pet,
Springer Spaniels are also excellent sniffer dogs and are often used
for search and rescue.

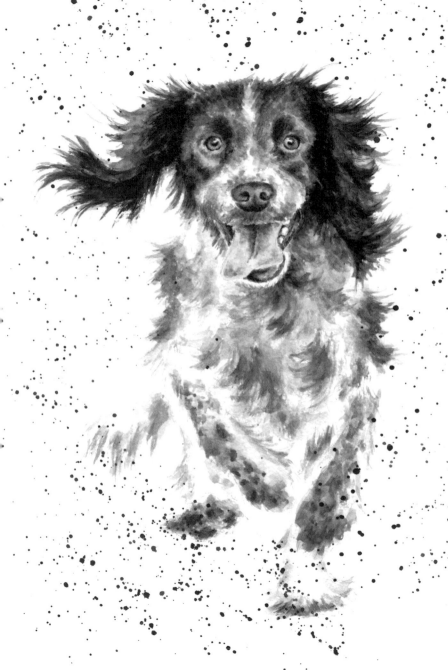

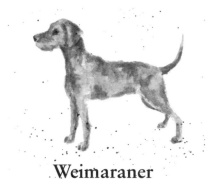

# Weimaraner
*Wilful • Wise • Aristocratic*

The Weimaraner is a beautiful and athletic dog. Its haunting, ghostly appearance is instantly recognisable with its velvety grey coat and amber eyes. The Weimaraner was originally bred in Germany as a dog for hunting large game such as deer, boar and bears and is an excellent all-round hunter and pointer. It was bred exclusively for the aristocracy and, as a highly-prized dog, it was kept inside with the families rather than outside in kennels. This has resulted in a dog with a strong need to be with humans – it is deeply unhappy without its companions. A lively and friendly dog, the Weimaraner has rightly earned a place in the hearts of dog lovers and makes a wonderful pet for those who can provide assertive leadership and lots of exercise.

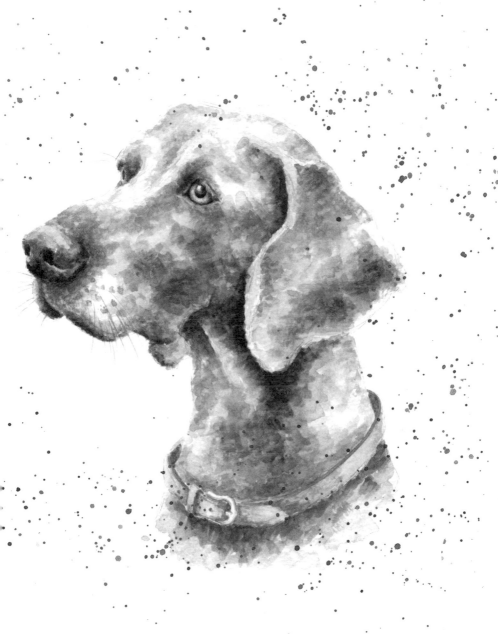

# Pastoral Dogs

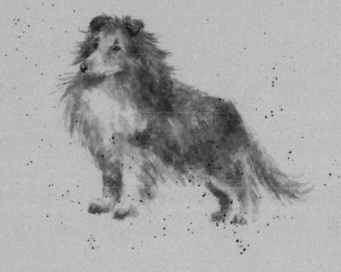

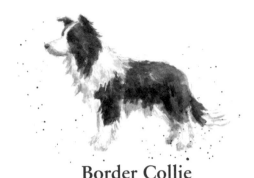

# Border Collie

*Clever • Strong-minded • Trustworthy*

The beautiful Border Collie, with its distinctive markings is the
brightest of all dog breeds, being highly intelligent, energetic and
athletic. Famous for excelling in doggy sports and sheepdog trials,
the Border Collie is the high achiever of the dog world. Originally
bred for herding sheep in the hilly borders of Scotland, obedience
and intelligence were the most prized characteristics. It is thought
that all Border Collies alive today can be traced back to a dog named
'Old Hemp', born in Northumberland in 1893. Though black and
white Collies are the most common, they can come in a wide variety
of colours including tricolour, red, brindle or blue. Although they
make wonderful companions, they need a lot of exercise and mental
stimulation to remain healthy and happy.

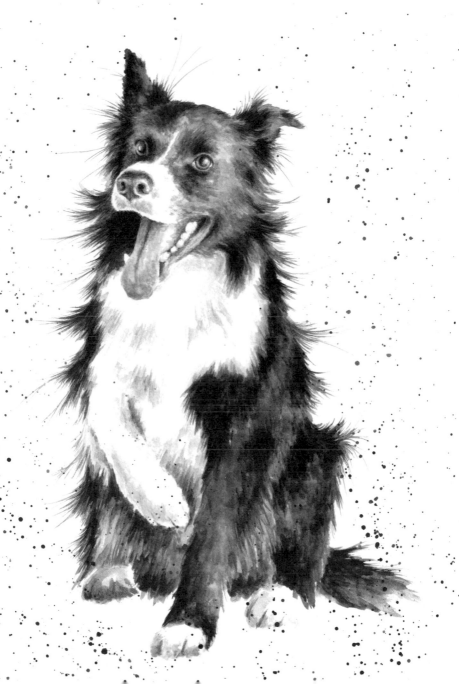

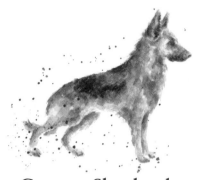

# German Shepherd
## *Patient • Confident • Gentle*

The German Shepherd is a relatively young breed, originating
in around 1900. It was bred for herding sheep, but its strength,
obedience and intelligence has led to it finding a calling in other
fields. As one of the brightest of all dog breeds, the German
Shepherd has a particular talent for police and military work. It has
an excellent sense of smell and is used as a detector dog as well as
a companion dog for the disabled. In the Second World War, the
German Shepherd came into its own as a messenger, rescue and
guard dog. Perhaps this was the start of its popularity as a pet –
many soldiers adopted the dogs after the war, impressed with their
intelligence and bravery.

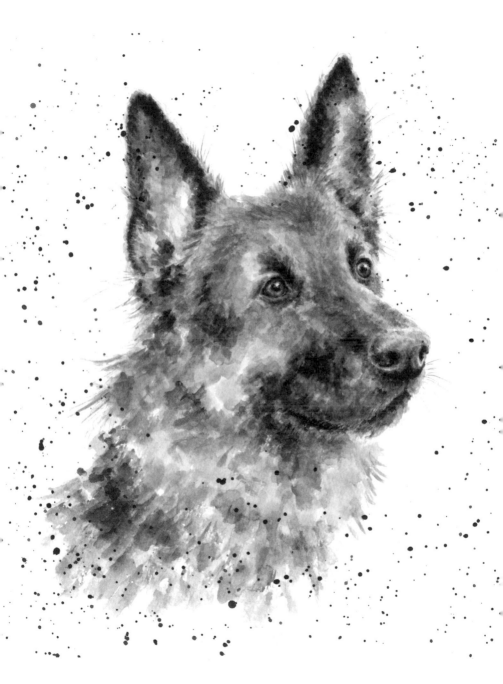

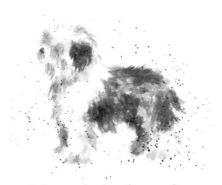

# Old English Sheepdog

*Good-natured • Enthusiastic • Peaceful*

The Old English Sheepdog is immediately recognisable with its silver and white shaggy coat and teddy bear-like appearance. It has been immortalised in popular culture many times – children remember with affection 'Barney' from the story books bearing the same name, Colonel in *101 Dalmatians*... and who can forget the Dulux dog? As the name suggests, the Old English Sheepdog was developed in England for the purpose of herding sheep. It is known to be an ancient breed – a 1771 painting by Thomas Gainsborough features a dog looking very much like an Old English Sheepdog. With a gentle but exuberant personality, this appealing dog is a true couch potato and a loving family member.

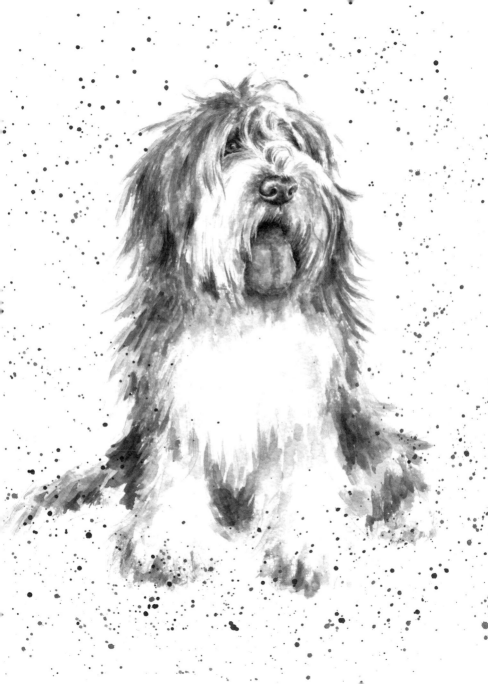

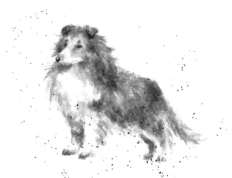

# Shetland Sheepdog
## *Dainty • Alert • Intuitive*

The beautiful Sheltie is one of the brightest dog breeds, with a sweet
and soft temperament. Although it could be mistaken for a small
version of the rough collie, it is a distinct breed. Hard-working,
intelligent, vocal, energetic and eager to please, this attractive little
dog has left behind its island roots and is now most commonly
found as a family pet or farm dog. It is thought that the Sheltie
is directly descended from a Collie, crossed with numerous other
breeds. It was bred to herd sheep on the Shetland Islands, where
the rough coastline and tempestuous climate was suited to smaller,
sturdier breeds such as the Shetland pony and smaller sheep breeds.
A kind and gentle herding dog, it soon found its way into the hearts
and homes of its human friends.

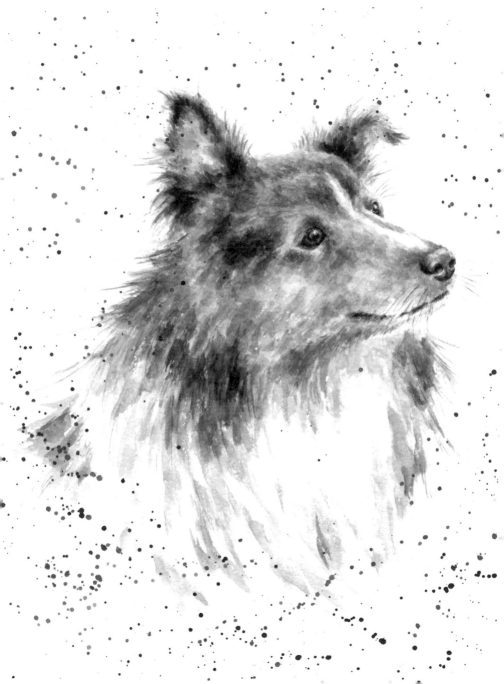

# Working Dogs

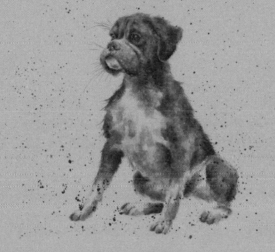

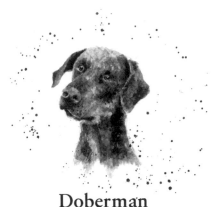

# Doberman
*Sensitive • Obedient • Strong*

The Dobie, as it is affectionately known, is a 'new kid on the block' as far as dog breeds go, being first developed in the late nineteenth century. It was the creation of a German tax collector named Louis Dobermann. Collecting taxes at the turn of the century from some of the most dangerous areas in the cities was not for the faint-hearted, and being a dog enthusiast, Dobermann wanted to create a breed that would offer him some protection as well as being a loyal companion. With its proud stature and imposing looks, the Doberman certainly fulfils that role. A natural protector, it is affectionate with family and trustworthy around children. Despite having a fearsome reputation, the Dobie doesn't go looking for trouble but is very territorial and adept at protecting its family if necessary.

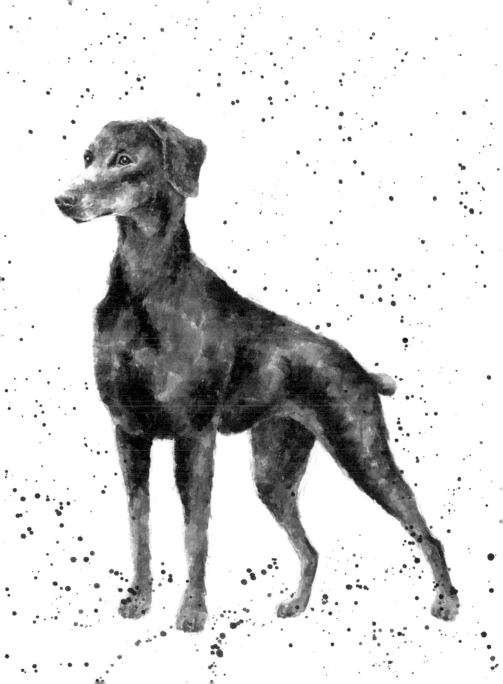

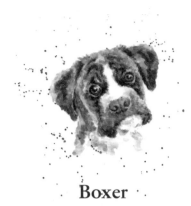

# Boxer

*Fun • Fearless • Animated*

The handsome Boxer is unforgettable with his distinctive face, sleek body and clown-like personality. Originally hailing from Germany, the Boxer was first bred for bull-baiting and was later put to use as a butcher's dog, where its strength and agility made it ideal for herding and controlling cattle in slaughterhouses. Despite its powerful looks, Boxers are gentle dogs – bright, energetic, playful and good with children. They are well known for being patient and protective. The Boxer name is a bit of a mystery – some thought that it arose from the dog's habit of standing on its hind legs and 'boxing', but the truth is unknown.

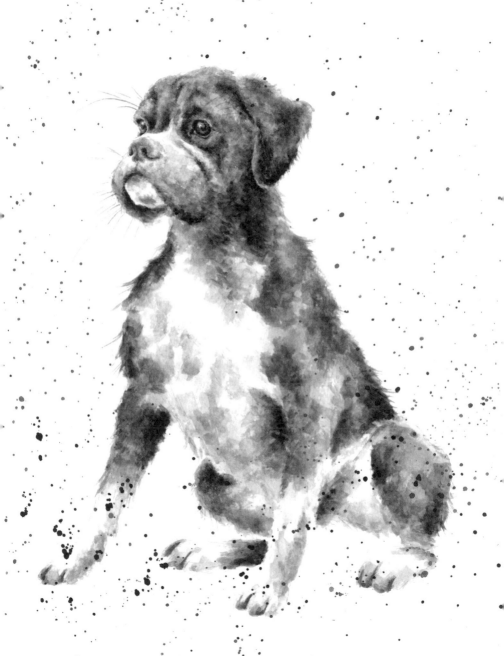

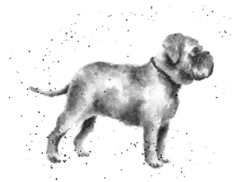

# Dogue de Bordeaux
## *Sensitive • Powerful • Calm*

The Dogue de Bordeaux shot to fame alongside Tom Hanks in *Turner and Hooch*. As Hanks no doubt discovered, having been completely outshone by his canine co-star, Dogue de Bordeaux are fantastic actors. Their faces are extremely expressive and you will certainly know when you are in the dog house! Fearless and powerful but sweet and docile, the DDB becomes extremely attached to its owners and takes its role as the family protector very seriously. However, this is a dog that knows its own mind and very much has a 'what's in it for me' attitude, making it notoriously difficult to train. The DDB is an ancient French Mastiff, with evidence for its existence as far back as the fourteenth century in the Bordeaux region of France.

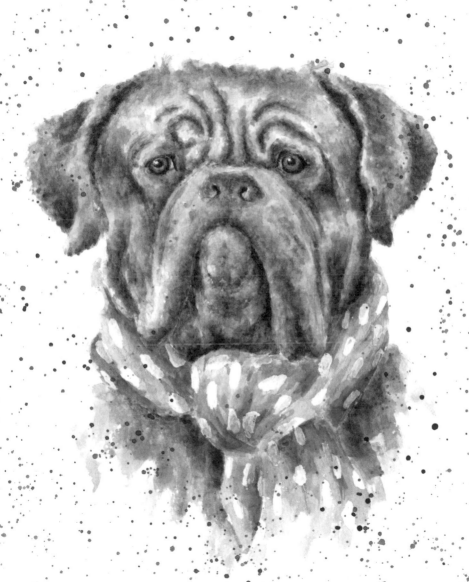

# Great Dane

## *Mild-mannered • Boisterous • Imposing*

The gigantic Great Dane is well known for its enormous stature. In fact, the holder of the world record for the tallest dog is a Great Dane known as Zeus, standing tall at 44 inches (112cm) from paw to shoulder. Large dogs resembling the Dane are seen throughout history, however, the dog we know as the Great Dane was actually developed in Germany. It is known there as the Deutsche Dogge, or German Mastiff. It was bred originally for hunting large game such as bears, deer and boar as well as for protection. Despite its imposing and slightly intimidating appearance, the Great Dane is actually a friendly and gentle dog that loves nothing more than sitting and leaning on its owner – it is often described as an oversized lapdog.

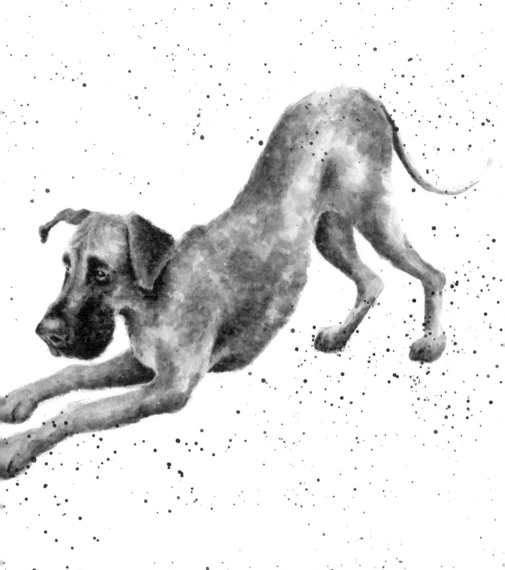

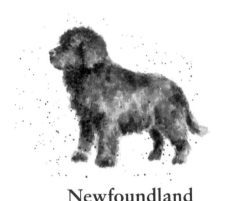

# Newfoundland
*Strong • Well-mannered • Loyal*

Legend has it that the Newfoundland was descended from the
black bear that roams the plains of Canada. It is no wonder – the
enormous Newfoundland has a distinctly bear-like appearance,
not dissimilar from an overgrown teddy bear. Despite its size,
the Newfoundland is the original 'gentle giant', famous for its
intelligence, strength, calmness and loyalty. It was famously depicted
as the nanny dog 'Nana' in *Peter Pan*. Originally bred as a working
dog by Canadian fisherman, it has webbed feet and a waterproof
coat and is a powerful swimmer with enormous stamina, highly
prized by the early settlers in the fishing communities. The
Newfoundland's true heritage is unknown – some think that it
descended from Viking 'bear dogs' and others believe it is closely
related to the Labrador.

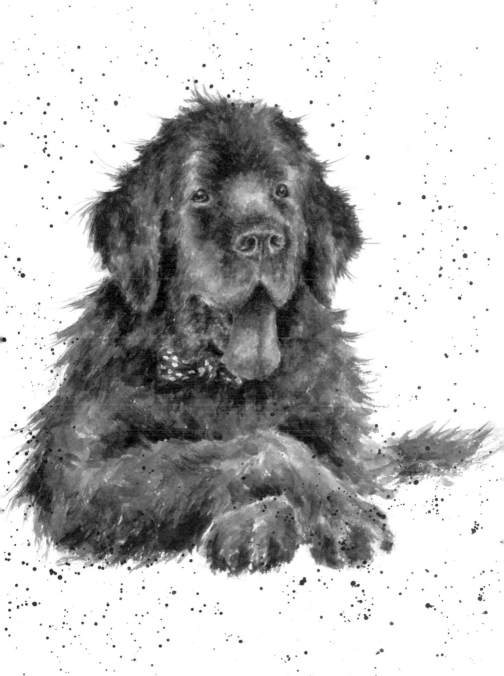

# Rottweiler

*Loyal • Steadfast • Confident*

The Rottweiler is probably the most misunderstood of all dogs.
Often portrayed in the media as vicious and aggressive, despite its
large size and immense strength, the reputation has been unfairly
earned. A Rottweiler is actually extremely loving and good-natured,
playful and utterly devoted to its owners. It is extremely protective
of its family, and must be well trained due to its strength and power.

The Rottweiler is one of the world's oldest herding dogs. It is
thought that its origins lie as far back as Roman times. It was named
after the town of Rottweil in Germany. The Rottie came into its own
during the First and Second World Wars when it served as a military
dog, excelling as a messenger, guard and rescue dog.

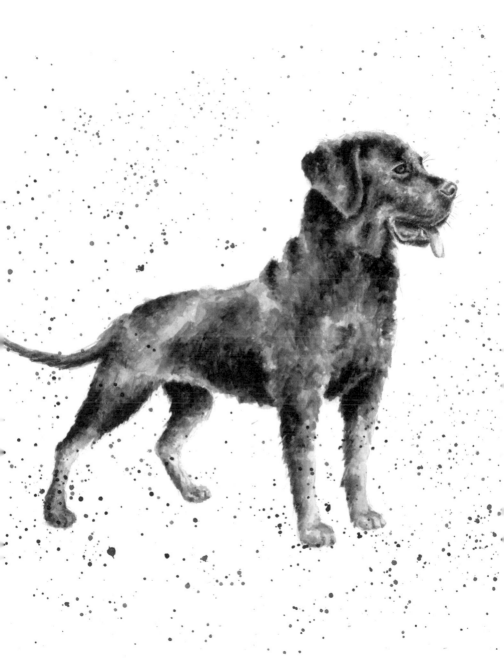

# Utility Dogs

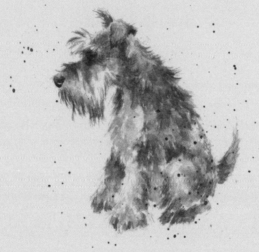

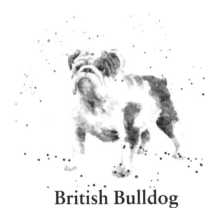

# British Bulldog
*Protective • Stubborn • Friendly*

Despite its rather grumpy-looking face, the Bulldog is one
of the friendliest and most sweet natured dogs, well known for
developing strong and protective bonds with children. It is extremely
distinctive, with its muscular body, turned up nose and thick folds
of skin around the face and neck. The Bulldog is first mentioned
in literature around 1500 and was originally bred to be used in
bull-baiting where several dogs were set against a tied bull. It was a
vicious and cruel sport, with many dogs being trampled or mauled
in the process. They were bred to have strong bodies, huge, muscular
jaws and a ferocious temperament. Thankfully, this inhumane sport
was outlawed in England in 1835 and today's Bulldog has lost its
ferocity and is much less athletic than its predecessors.

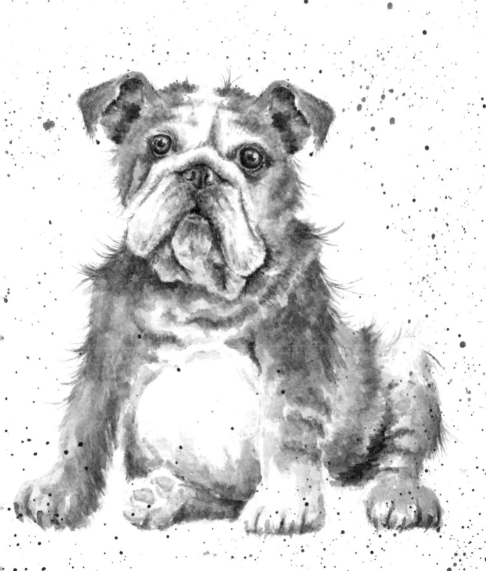

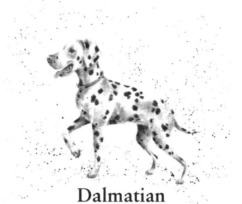

# Dalmatian
*Clumsy • Sociable • High-spirited*

The Dalmatian is one of the most easily recognised and iconic
of all dogs, made famous in Dodie Smith's novel, *101 Dalmatians*.
Born white, they develop their distinctive spots after three to four
weeks. It is thought that the breed originated in Croatia, but there
is evidence of spotted dogs throughout history. They are brilliant
guard dogs and it is likely that they were dogs of war, bred to guard
borders. Historically used in all sorts of hunting, then later used
as carriage dogs, their long legs and athletic build making them
ideally suited to their jobs. They have a strong affinity with horses
and will guard them overnight. Dalmations are very energetic and
need lots of daily exercise but are playful and intelligent and make
wonderful pets.

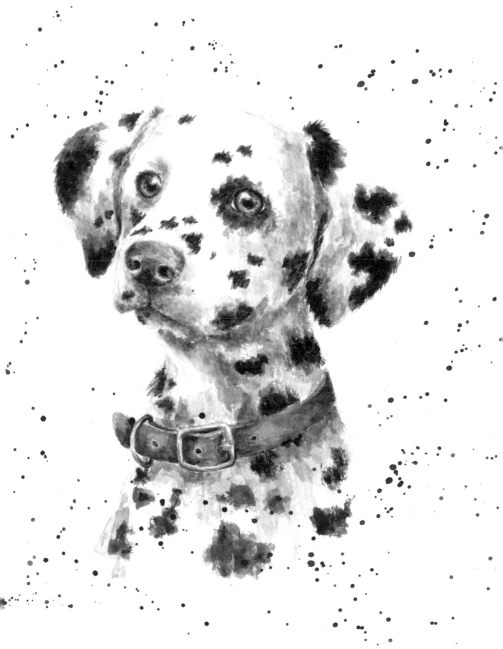

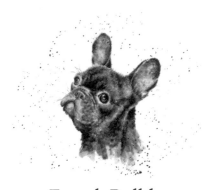

# French Bulldog
*Mischievous • Entertaining • Expressive*

The Frenchie is enjoying something of a resurgence of popularity, especially in towns and cities where this sweet little dog is well adapted to apartment life. Contrary to what its name would suggest, the Frenchie was first bred in England to be a companion, or toy version of the Bulldog. It was a particular hit with the lace makers of Nottingham, and when they emigrated to France to seek better opportunities, they took their little dogs with them, and that is where they adopted their French name. The Frenchie lavishes love on its human friends, and demands to receive it in return. Funny, mischievous and gentle, with its comical bat ears and big, expressive eyes, there is no wonder that this breed is enjoying a renaissance.

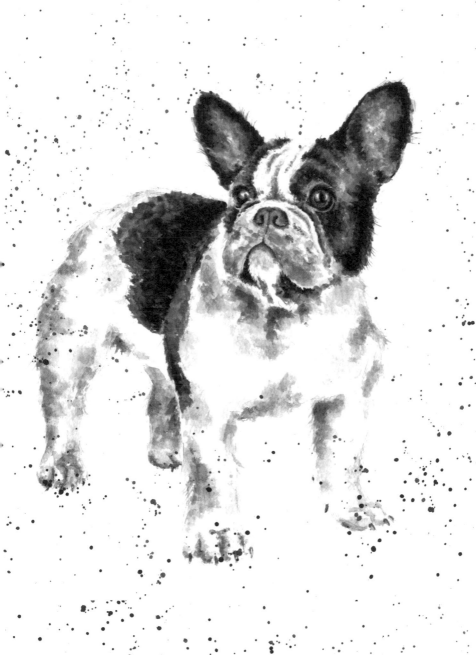

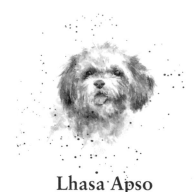

# Lhasa Apso

*Fun-loving • Assertive • Smart*

Don't be fooled by the diminutive size of the Lhasa Apso – this
is a dog with an enormous personality. One of the most ancient
breeds in the world, it is also one of the most closely related to the
ancestral wolves. Bred in Tibet – Lhasa being the capital of Tibet,
'apso' meaning 'bearded', the monks used it as a guardian of the
monasteries. A legacy of this is that the Lhasa has a great sense
of hearing but is suspicious of strangers. The breed finally made
its way to England in around 1900. The Lhasa has a characteristic
heavy, straight and dense coat that can be a variety of colours, and
a fantastic beard. It is incredibly independent but fiercely loyal. If a
Lhasa doesn't want to do something, you soon know about it!

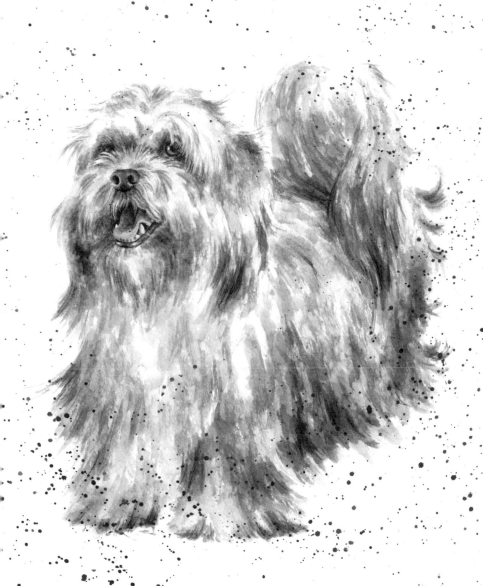

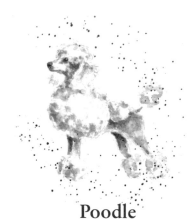

# Poodle
*Faithful • Excitable • Nervous*

The Poodle is one of the most recognisable and iconic of all breeds, often parodied for the eccentric haircuts it has become famous for. However, the bouffant hair and pompom tails belie one of the smartest and most trainable dogs on the planet. This lively dog is an expert at learning patterns, which means it is eerily able to anticipate your next move, and many Poodle owners feel that their pets have a telepathic ability. The Poodle was originally bred in Germany to hunt ducks. Its webbed feet and love of swimming are a legacy of this heritage. The name 'Poodle' is thought to come from the German 'pudelhund', or 'puddle hound'. Soft and sensitive, the Poodle also has a reputation for being highly strung but handled well they make loving, loyal pets.

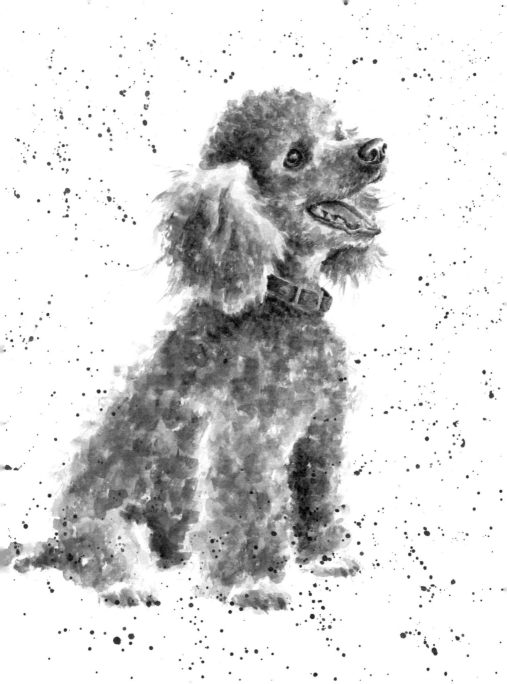

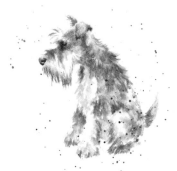

# Miniature Schnauzer
*Funny • Intelligent • Noisy*

Although it looks like a smaller version of the Schnauzer, the
Miniature Schnauzer is in fact a distinct breed. It was originally
bred by crossing the larger Schnauzers with a smaller dog, such as a
Poodle or Affenpinscher, in order to create a diminutive Schnauzer
with a big personality. It was used as a rat catcher, yard dog and
general guard – it will certainly let you know if you have an intruder
in the house! The word 'schnauzer' means 'snout' and probably
refers to the whiskery muzzle the breed is famous for, along with its
feathery eyebrows. A typical terrier, the Miniature Schnauzer is an
extrovert, playful and clever, but it tends to be a little less feisty than
some terrier breeds, and makes an excellent family pet.

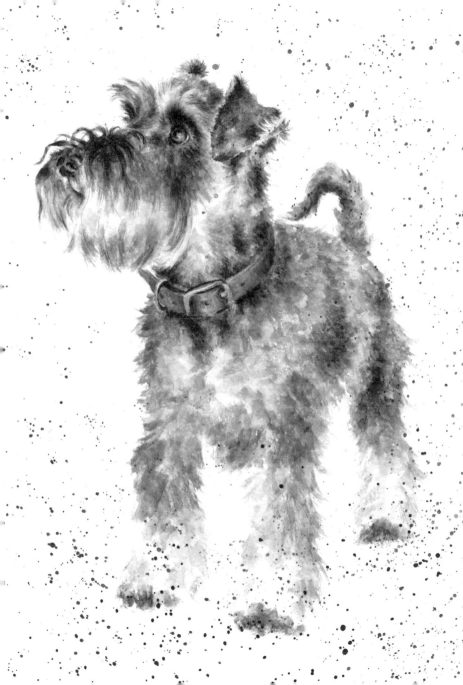

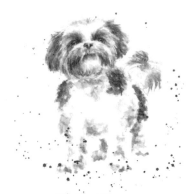

# Shih Tzu

*Feisty • Cuddly • Persistent*

The Shih Tzu, with its large eyes, short muzzle and long coat is
an ancient breed, thought to have originated in Tibet before being
taken to China. A favourite amongst Chinese royalty, the name
means 'lion dog' and it is thought that the Shih Tzu was bred to look
like the lions that appear in traditional Chinese art. These little dogs
were so highly prized that the Chinese refused to sell or trade them
for centuries. The first of the breed were finally imported to Europe
in 1930. Since then, the Shih Tzu has become extremely popular.
Known as the 'chrysanthemum dog' when it first arrived here, it is
less demanding than other toy dogs. Playing in the garden usually
offers enough exercise, and it loves nothing more than cuddles and
attention, making it an ideal companion dog.

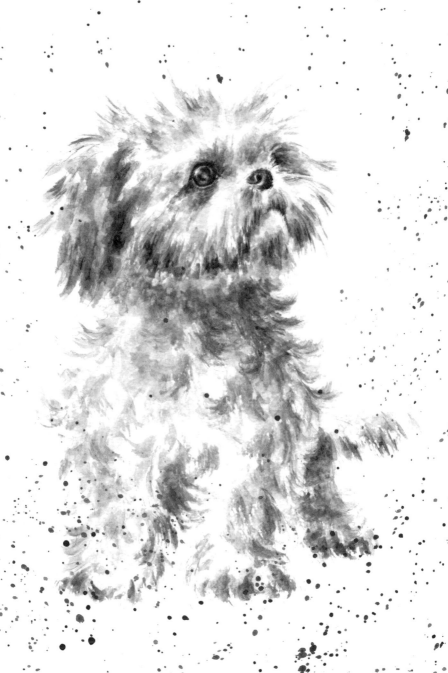

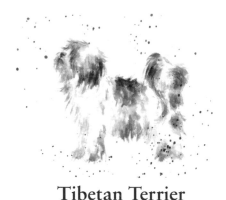

# Tibetan Terrier
*Cheeky • Clever • Good-natured*

As the name would suggest, the Tibetan Terrier hails from none other than Tibet. Its Tibetan name is Tsang Apso, meaning 'bearded dog'. It is one of the most ancient breeds, thousands of years old, and was historically kept as a good luck charm as well as being a watchdog, sheep herder and all-round companion. The dogs were never sold, but were given as gifts by monks to promote good fortune. They were referred to by the monks as 'the little people'. The Tibetan Terrier's thick and lustrous coat was perfect for the cold, mountainous climate of Tibet and its distinctive, broad feet act as natural snowshoes. Tibetan Terriers still love nothing more than a romp around in the snow.

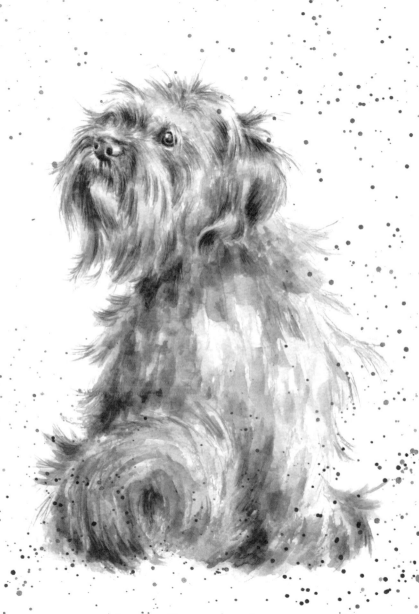

# Terriers

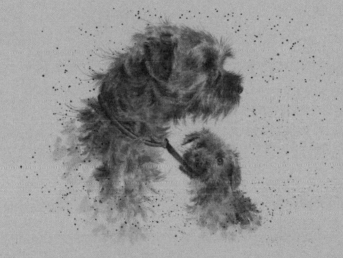

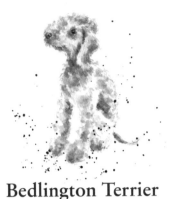

# Bedlington Terrier

*Energetic • Inquisitive • Brave*

The adorable Bedlington Terrier hails from the mining town
bearing that name in Northumberland and was originally bred to
hunt mice and rats in mines. It is thought that they are related to
the Dandie Dinmont, the Whippet and the Otterhound. A 'terrier
in lamb's clothing', the Bedlington is a tale (tail?!) of two halves.
As its lamb-like appearance would suggest, the Bedlington is good
with children, kind and affectionate. However, as with all terriers,
this plucky little dog can hold its own in a fight and is an adept
dispatcher of vermin, demonstrating tenacity and intelligence
when pitted against a rat.

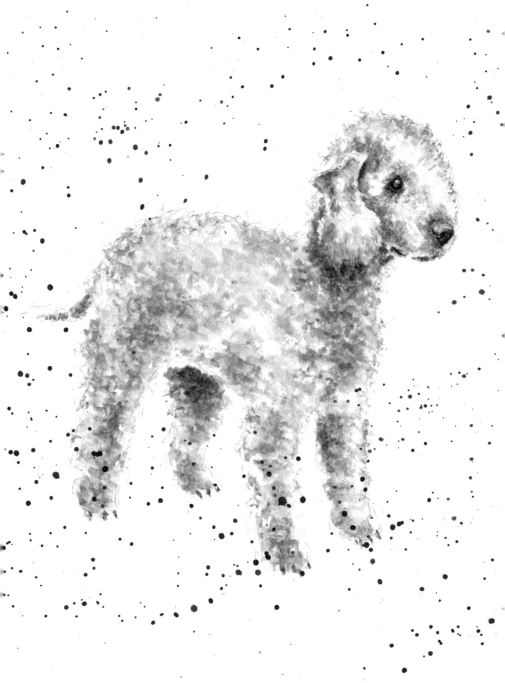

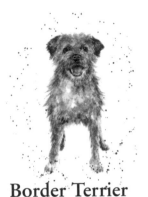

# Border Terrier

*Gregarious • Alert • Tenacious*

The Border Terrier is a small but sturdy, rough coated terrier with a gorgeous whiskery face, bred to hunt fox and small vermin. Originally known as the Coquetdale or Redesdale Terrier, it had adopted the name 'Border' Terrier by the 1800s because of its long association with the border hunt in Northumberland. A tenacious little dog, it still proves to be a formidable foe to rats and other small vermin, and may or may not live peacefully with the cat… Despite this, the little border is a friendly and mild-mannered terrier, rarely shows any aggression and there is little wonder it is a favourite amongst many families.

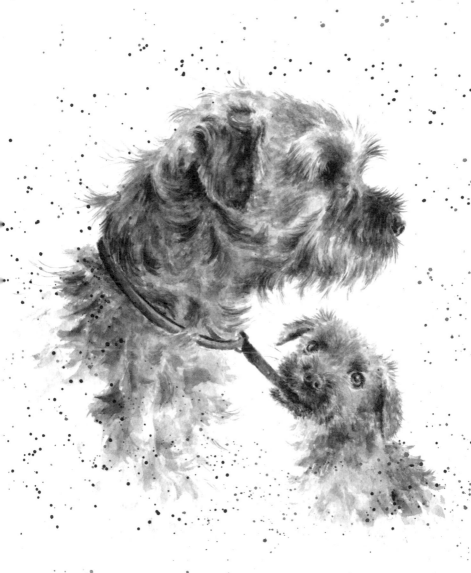

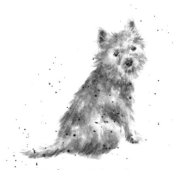

# Cairn Terrier
*Feisty • Plucky • Spirited*

Often mistaken for the Westie, it is perhaps unsurprising as the
Cairn Terrier also hails from the Highlands of Scotland. It was
originally grouped together with the Westie and the Scottie as a
'Skye Terrier' – it wasn't until the early 1900s that the three breeds
began to be viewed as distinct breeds and bred separately. The
Cairn has a wiry, weather-resistant coat as befitting a dog from the
Highlands. It comes in a variety of colours, unlike the white Westie.
Bred to hunt vermin, the Cairn is still an efficient dispatcher of mice
and rats, and has a typically feisty terrier personality, but is also a
much-loved, faithful and endlessly fun family friend.

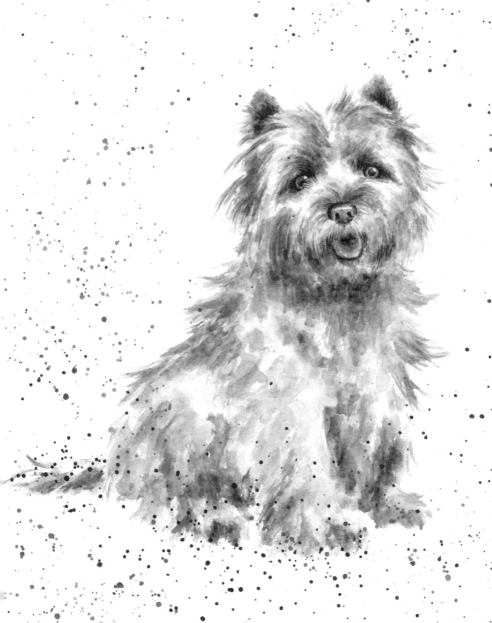

# English Bull Terrier
*Loyal • Boisterous • Determined*

The English Bull Terrier is instantly recognisable with its egg-shaped head, small triangular eyes and stocky, muscular body. A fun-loving and busy dog, it is always keen to be in the centre of the action and is as happy playing in the garden or snuggled on the sofa as it is out and about. First bred in the 1800s, the English Bull Terrier is the cross of a Bulldog and a terrier. The idea was to create a dog that combined the speed and agility of a terrier with the strength and tenacity of a Bulldog. In the mid-1800s, white Bull Terriers were known as the White Cavalier due to their gentlemanly behaviour but courage in battle – it was said that they would never start a fight but would be able to finish one.

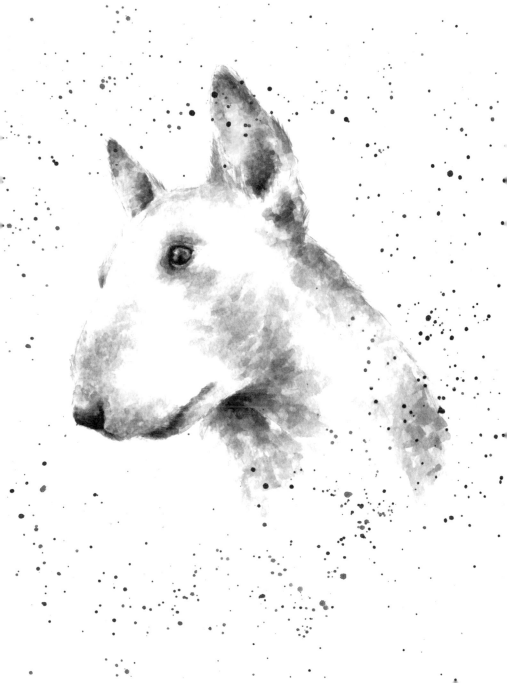

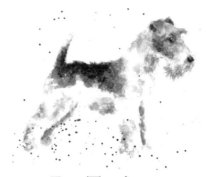

# Fox Terrier

*Curious • Dynamic • Stubborn*

The feisty Fox Terrier was bred to flush foxes out of their hiding places during hunts. There are two distinct breeds – the wire-coated and the smooth-coated. White, smooth-coated, easy-to-spot dogs were highly prized for hunting, while the wire-coated versions were preferred for hunting over rough ground as their coat offered more protection. This little terrier has a big personality and has retained a strong prey drive from its hunting heritage. Small animals will stand little chance against this tireless hunter, and it will dig with reckless abandon if it picks up a scent. Fearless and plucky, it is not afraid to pick a fight with much bigger dogs… with varying results. The Fox Terrier is an intelligent dog; outgoing, active and inquisitive, and makes a wonderful family member and vocal watch dog.

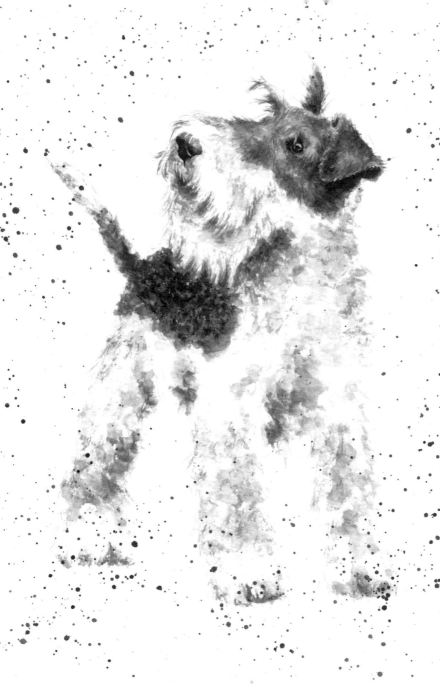

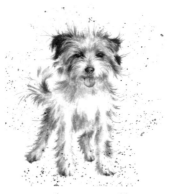

# Jack Russell
## *Nosy • Independent • Outgoing*

Jack Russells are the small dogs with a great big attitude. They first
made their appearance when the Reverend John Russell bought a
white fox-hunting dog from his local milkman. The dog exemplified
everything the Reverend wanted in a hunting dog, and it was upon
this female that he based his breeding programme, resulting in this
bold and fearless little dog with boundless energy, quick intelligence,
determination and strong hunting instinct. Jack Russells are
notorious escape artists, not above climbing, jumping
or digging their way out in their tireless pursuit of fun. This
energetic and spirited dog makes a companion that will fill
your days with endless love and laughter, but make no mistake,
you won't be the one in charge!

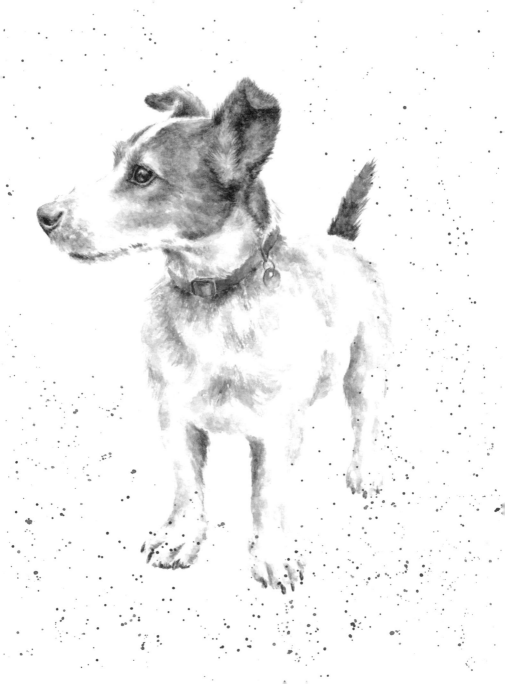

# Patterdale Terrier
*Loving • Bold • Independent*

The Patterdale Terrier was named after the town of the same name in Cumbria. The breed was developed in an environment where the land was mostly used for sheep farming, and Patterdales were used to keep down vermin and foxes, which were seen as a threat to the sheep. As such, they were bred to 'catch and despatch', swiftly and efficiently. The Patterdale is still a tenacious ratter and an excellent digger if it picks up a scent. Laid-back and a little less yappy than your average terrier, the Patterdale likes its home comforts and will enjoy basking in the warmest spot in a room. It is just as determined and tough as any self-respecting terrier and can be a little difficult to train due to its independent nature and stubborn streak.

# Scottish Terrier

*Feisty • Canny • Thoughtful*

Possibly most famous for being the Monopoly piece everyone
fights over, the Scottie dog is instantly recognisable with its bushy
eyebrows and whiskery beard. Also immortalised as Jock in Disney's
*Lady and the Tramp*, the loveable rogue is most peoples' perception
of a perfect Scottie – resolute and stubborn but kind, brave and
tenacious. In fact, a Scottie is a very typical terrier, being feisty and
determined. This compact and sturdy little dog certainly has a mind
of its own but is a good friend to its family and is very loyal. All of
today's Scotties can be traced back to a single female called Splinter.
The dogs were originally bred in the Highlands for hunting vermin,
badgers and foxes.

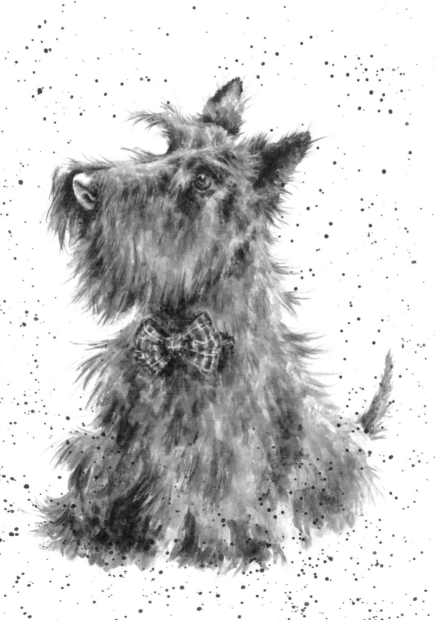

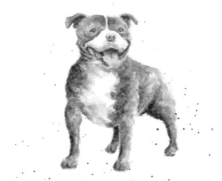

# Staffordshire Bull Terrier
## *Gentle • Loyal • Tolerant*

Despite its muscular body and powerful jaws, the Staffordshire Bull
Terrier is one of the sweetest and most loving dogs you can find. In
the nineteenth century, bull- and bear-baiting had been outlawed, so
underground dog fighting became all the rage. Descended from the
bulldog, the Staffy was originally bred in the Midlands as a small
and plucky fighting dog that was also friendly towards humans. The
legacy is a dog that is sensitive and loyal, brave and intelligent. It is
known as the 'nanny dog' for its love of children, but it can be less
keen on other dogs. A breed that doesn't deserve its reputation as a
thuggish dog, a finer companion is hard to find.

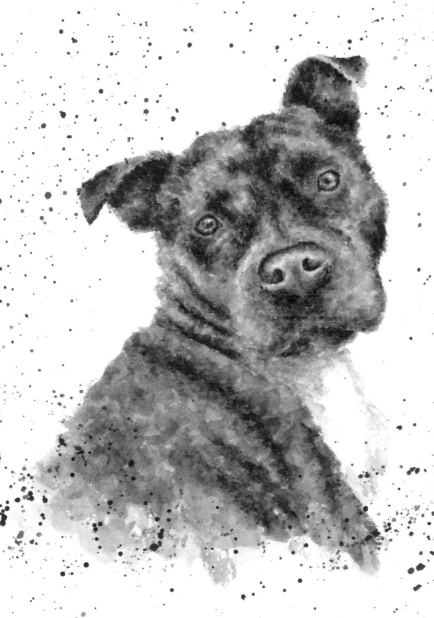

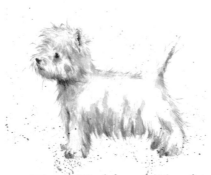

# West Highland Terrier
*Bold • Assertive • Cheerful*

The West Highland Terrier, or Westie, has a sweet face that belies a bold and assertive little dog with an inquisitive nature and a wicked sense of fun. There's no wonder it is such a well-loved breed throughout the world. The Westie was bred in Scotland originally to hunt foxes, otters and vermin. Although there is evidence of ancestors as far back as the 1500s, it wasn't until the nineteenth and twentieth centuries that the breed was developed into the dogs we see today. It is said that the Laird of Poltalloch was hunting with his dark-coated dog and accidentally shot it, mistaking it for a fox. He was so devastated that he vowed to hunt only with white dogs from that day on, and dedicated himself to breeding the terriers we now know and love.

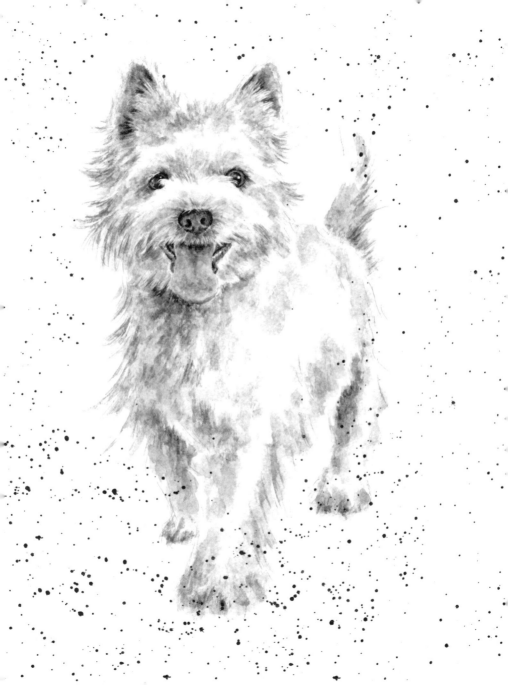

# Hounds

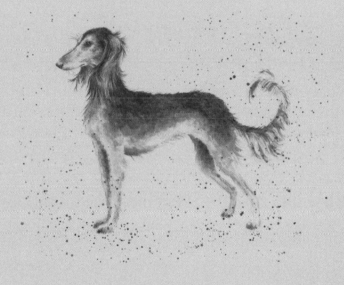

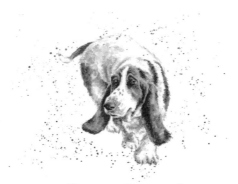

# Basset Hound

*Pleasant-natured • Easy-going*
*• Sociable*

The short-legged Basset Hound is amongst the sweetest-natured dogs around. A scent hound, it has an amazing sense of smell and was originally bred in France to hunt rabbits. Its long, droopy ears help to trap the scent, aiding detection. The word 'basset' comes from the French 'bas' meaning 'low' – the breed is characterised by its solid, short appearance with long ears and a long, curved tail. The Basset's loose skin gives it a sad expression, in contrast to its friendly and sweet personality. Its long body will ensure that any tasty snack left on a sideboard will soon be within reach… and it won't last for long. Bassets have been represented many times in popular culture, giving them a special place in our affections – Fred Basset and Hush Puppies being notable.

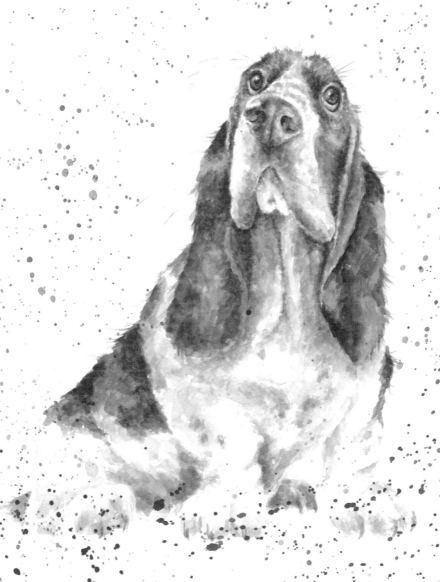

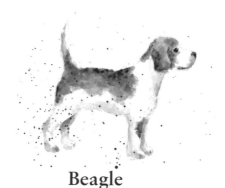

# Beagle
*Greedy • Independent • Wanderer*

The Beagle is a scent hound with one of the best senses of smell of all breeds. Beagle-like dogs have been around for thousands of years – there is evidence of dogs with a similar size and appearance in the fifth century BC, and they have been depicted in literature since Elizabethan times. Of course, the most famous and endearing beagle of them all is Snoopy. Elizabeth I was said to be a particularly devoted Beagle owner. She was fond of a smaller version known as a 'pocket Beagle' and used to let them run along the table at meal times, to the delight (or horror) of her guests. Today, the energetic Beagle is a much-loved family favourite, with its beautiful face and friendly personality.

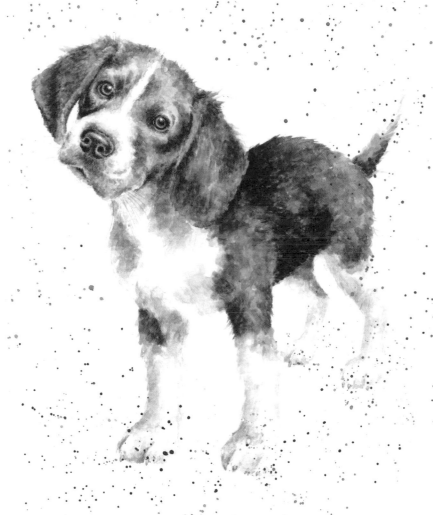

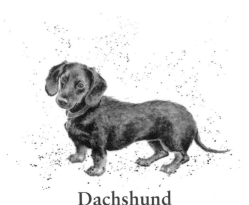

# Dachshund
## *Determined • Greedy • Curious*

The 'badger dog' was originally bred to find and flush out badgers
in Germany. It is deep-chested with a large lung capacity, giving
it excellent stamina. It has a good sense of smell, loose skin that
doesn't tear when crawling in tight burrows, and floppy ears to stop
seeds getting inside. Its long, curved tail allows the diminutive dog
to be spotted in long grass and also acts as a convenient aid to pull it
out of burrows if necessary. With its original purpose now behind it,
the 'sausage dog' makes a popular pet, with many famous devotees
throughout history, including Queen Victoria, Andy Warhol and
John F. Kennedy. It can be smooth, long-haired or wire-haired, each
variety with its own character quirks. Affectionate and playful,
Dachshunds definitely have a mind of their own!

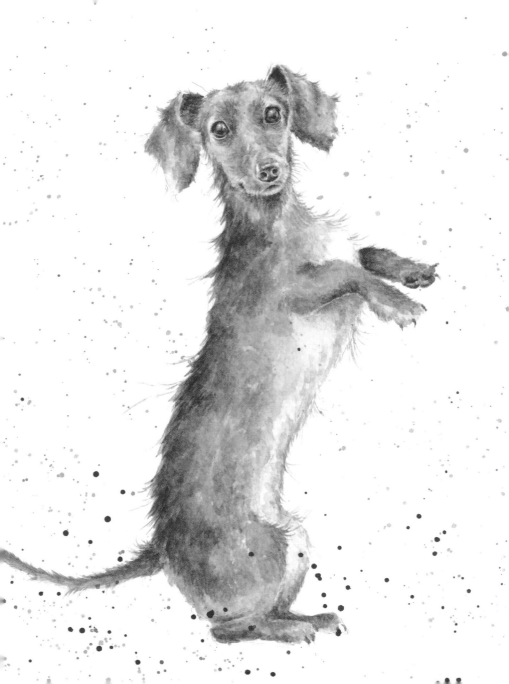

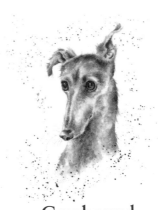

# Greyhound
*Gentle • Undemanding • Graceful*

Slender and graceful with a sleek, smooth coat, the Greyhound
was bred for coursing in open country and as a racing dog. Various
theories exist about the origin of this ancient breed, ranging from
Ancient Egypt to being first bred by Celts in Europe. Greyhounds
are built for short bursts of speed rather than endurance, and as
long as they get a daily opportunity to stretch their long legs, they
are happiest lounging the rest of the day away in the company of
their human friends – Greyhounds can sleep up to 18 hours a day!
Having said that, they have a strong prey drive and do love to chase
small creatures. The breed has increased in popularity as a pet since
charities began rehousing ex-racing dogs and people realised how
gentle, intelligent and kind they are.

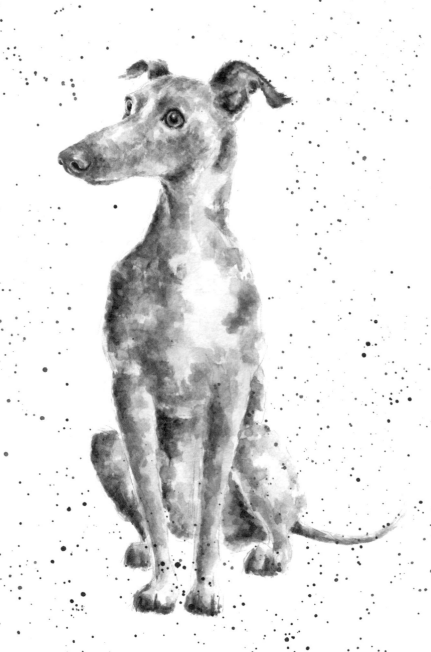

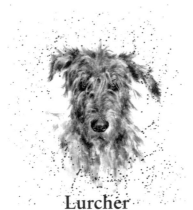

# Lurcher

*Enigmatic • Regal • Loving*

A Lurcher is defined as any sighthound (such as a Whippet,
Greyhound or Saluki) crossed with another type of dog – usually a
terrier. Although not a distinct breed in its own right, it is one of the
oldest hybrid dogs and is recognised as a good 'all-rounder', often
kept as a family pet or loving companion. Lurchers were the original
'poachers' dog', bred for speed, intelligence and tenacity. Because
of their varying parentage, appearance and behaviour can differ
between dogs, but the common pairing of a sleek and streamlined
sighthound with a wiry terrier often produces a gloriously leggy dog
with a wonderfully scruffy coat, full of character, that is perfectly
suited to these poaching pets.

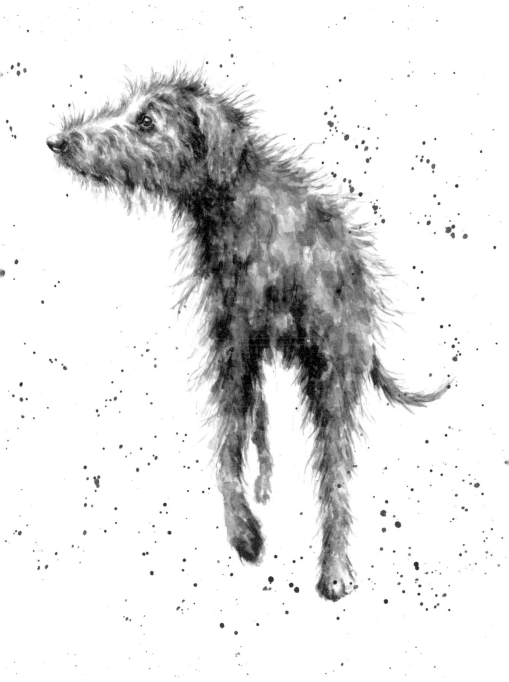

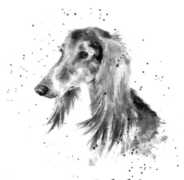

# Saluki

*Regal • Calm • Dignified*

The Saluki has to be amongst the most elegant of all dogs with its long limbs and flowing hair. A sight hound, its long legs and deep chest make it perfectly suited to chasing fast game, and the deep pads on its feet absorb the impact as it races after its quarry. An ancient dog breed, it is unsurprisingly related to the equally luscious Afghan hound. Dogs resembling a Saluki can be seen in Ancient Mesopotamian artwork and they are thought to have come from the 'fertile crescent', an area of land in the Middle East. The sleek and fast Saluki was used by nomadic tribes for hunting gazelles, hares and foxes. It was first brought to England in 1840, but didn't become popular until the 1920s when officers returned from the war in the Middle East, bringing these beautiful dogs with them.

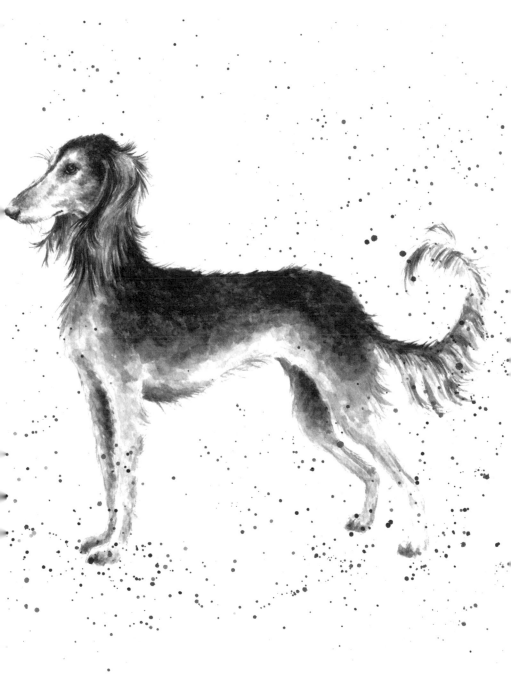

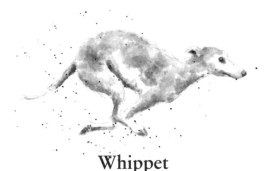

# Whippet
*Diva • Loyal • Lapdog*

The Whippet is a sighthound, directly descended from the Greyhound. It is thought that the breed came about because small Greyhounds that were thought unsuitable for hunting stags were returned to the peasants who had bred them. The dogs would be maimed in order to prevent them being used for poaching. However, the resourceful peasants bred the dogs and used them to hunt rabbits and rats. When the forest law was finally overturned, the Whippet found increasing favour. Although popular for racing, the Whippet is, at heart, a quiet and gentle dog, devoted to its owners and happy to spend most of the day curled up on their lap. It is a notorious food thief – even the most well trained Whippet will not be able to resist a tasty morsel left unattended…

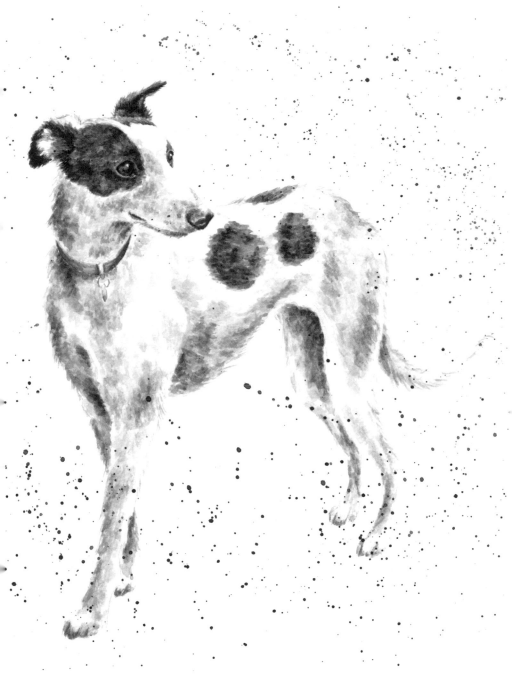

# Index

Other books in the series include:

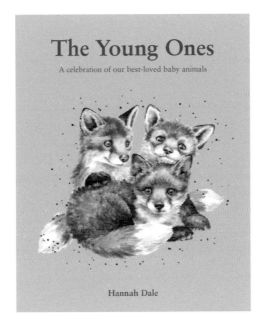

*The Young Ones*

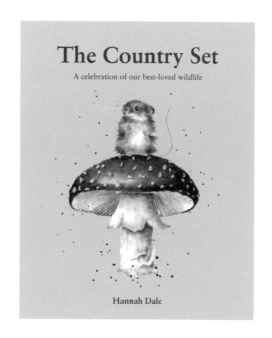

**The Country Set**

A celebration of our best-loved wildlife

Hannah Dale

*The Country Set*